P9-AQJ-793

modigliani

THE LIFE AND WORKS OF

MODIGLIANI

Janice Anderson

A Compilation of Works from the
BRIDGEMAN ART LIBRARY

SMITHMARK

Modigliani

This edition published in 1996 by SMITHMARK
Publishers, a division of U.S. Media Holdings, Inc.,
16 East 32nd Street, New York, NY 10016.
SMITHMARK books are available for bulk
purchase for sales promotion and premium use.
For details write or call the manager of special
sales, SMITHMARK Publishers, 16 East 32nd
Street, New York, NY 10016; (212) 532-6600
First published in Great Britain in 1996 by
Parragon Books Limited
Units 13-17, Avonbridge Industrial Estate
Atlantic Road, Avonmouth, Bristol BS11 9QD
United Kingdom

ISBN 0-7651-9898-3

Printed in Italy

Editors:　　　　Barbara Horn, Alex Stace, Alison Stace, Tucker Slingsby Ltd
　　　　　　　　and Jennifer Warner

Designers:　　　Robert Mathias and Helen Mathias

Picture Research:　Kathy Lockley

The publishers would like to thank Joanna Hartleyat the Bridgeman Art Library
for her invaluable help.

Amedeo Modigliani 1884-1920

Among the seething crowd of artists from all over Europe and beyond who made Paris in the early 20th century the most innovative and revolutionary artistic centre in the world Amedeo Modigliani stood out as much for his notorious life style as for his painting. However, it has been remarked of him that if he had never existed, the course of 20th century art would have gone on just the same. Yet he remains one of the greatest, if not the greatest, Italian painters of the 20th century and an artist whose style is recognized and his work coveted by people of all nationalities. Despite the fact that almost all his work was done in France, particularly Paris, where he lived most of his adult life, Modigliani, a superb draughtsman, was essentially a classical painter, an heir of Italian Renaissance art, particularly that of Botticelli.

Amedeo Clemente Modigliani was born in Livorno (Leghorn), Italy on 12 July 1884. He was the fourth and youngest child of Flaminio Modigliani and his wife, Eugénie Garson, members of a once well-off but now comparatively poor Sephardic Jewish family who had been established in Italy for many generations. Modigliani was ill as a child, and was never to be physically strong, an attack of typhoid and pleurisy in his teens leaving him with a tubercular lung.

Modigliani had shown signs of artistic talent early on, and when he was 15 he began to study at the school of the artist Guglielmo Micheli in Livorno. In 1901, after a period of illness, his mother took him to the warm south, to Naples, Capri and Rome where the young Modigliani had his first tastes of the glories of Italian art. He enrolled in the Academy of Fine Art in Florence in 1902, where the head was Giovanni Fattori, the famous Macchiaioli painter. From Florence, Modigliani moved to Venice,

where the already important Biennale exhibitions allowed him to discover the way in which Modern Art in Europe was moving.

By early 1906, Modigliani was in Paris, which was to be his artistic home for the rest of his life. By now he was painting and drawing feverishly, finding his place in the artistic life of the city. At first he seems to have been influenced by the work of Henri de Toulouse-Lautrec, but by 1910, when he exhibited six works in that year's Salon des Indépendants, the influence of Cézanne, whose work he first encountered in depth at a major retrospective in Paris in 1907, had become much more important, although his great admiration for African art and for what Pablo Picasso was doing, also played their parts in the development of Modigliani's art.

It was about this time that Modigliani began to concentrate on sculpture, his painting and drawing becoming very much studies for his sculpture. His sculpture was done in stone, an activity which put an enormous strain on his never strong physique and frail lungs. In 1912, he showed seven sculptured heads at the Salon d'Automne in Paris.

The outbreak of war in 1914 changed the course of Modigliani's life. Not only did it remove from Paris many of his circle of friends, including his first patron Dr Paul Alexandre, it also greatly diminished the art market of the day. At the same time, it deprived Modigliani of his sources of cheap or free stone for carving and prevented his allowance from home reaching him in Paris. The cycle of drinking in cafés with poverty-stricken refugees, of taking drugs, of living in damp, dirty studios without proper food became a way of life which Modigliani did not seem to want to change.

Through it all, however, he continued to paint. By 1915 he had virtually given up sculpture, though its influence would continue to have an effect on his painting and drawing, both of which he worked at feverishly. His work was a constant exploration of composition and structure, of line, diagonals and planes of colour in which he sought the way to artistic perfection.

By 1917, there might have been a chance for some sort of order in Modigliani's life. He had a loyal and enthusiastic dealer in Leopold

Zborowski, and a devoted mistress in Jeanne Hébuterne, with whom he enjoyed the closest relationship of his life, though even that was stormy and he was not above beating her up in public.

The deterioration in Modigliani's health continued as the war reached its climax. Life in Paris was hard, but Zborowski still managed to organise a big, one-man exhibition of Modigliani's work at the Berthe Weill Gallery at the end of 1917. It was closed down by the police, because of the large, erotic paintings of nudes in the gallery's window. Three months later Zborowski, seriously concerned for the artist's health, sent him and Jeanne down to the South of France. Though he disliked the climate and was irritated by the pseudo-family life with Jeanne, who was pregnant with their first child, and whose mother stayed with them, Modigliani produced many superb paintings, most of them of local people.

Jeanne gave birth to Modigliani's daughter, also called Jeanne, in November 1918. In May 1919, Modigliani returned to Paris, Jeanne and their baby following him a month later. Life returned to its old course, though by now the critics were taking an interest in Modigliani's work and the favourable reviews were increasing in number. Works by Modigliani were included to favourable notices in an exhibition in London and in the Salon d'Automne in Paris.

But the artist himself was sinking ever deeper into a pit of ill health aggravated by heavy drinking sessions in the cafés of Paris. In January 1920, his friends Ortiz de Zarate and Moïse Kisling, visiting his studio, found him delirious and in severe pain, lying in a bed strewn with empty bottles and sardine cans. They got him into hospital, where he died of tubercular meningitis on 24 January. The next day, Jeanne Hébuterne, heavily pregnant with their second child, jumped out of the fifth floor window of her parent's apartment, killing both herself and the child.

Amedeo Modigliani's funeral at Père Lachaise cemetary was attended by a large number of artists, including his close friends, deeply shaken by his death – and by numerous dealers, said to have been negotiating new prices for his pictures almost at the graveside.

▷ **Head of a Woman Wearing a Hat** 1907

Watercolour

LITTLE OF THE UNIQUELY forceful artist that Modigliani would become shows in this stylistically unremarkable portrait. It dates from the time in Paris when Modigliani had formed a close friendship with Dr Paul Alexandre, who became one of his most important patrons: over a five or six year period, Dr Alexandre was to acquire some 25 portraits and dozens of drawings by the artist. The model for this painting is thought to have been the same girl, possibly one of Dr Alexandre's patients, who modelled for the major oil portrait, *The Jewess*, which Modigliani completed in 1908. The flat colour planes and strongly graphic approach suggests that Modigliani may have had it in mind to make the picture the basis of a poster or some other form of graphic reproduction.

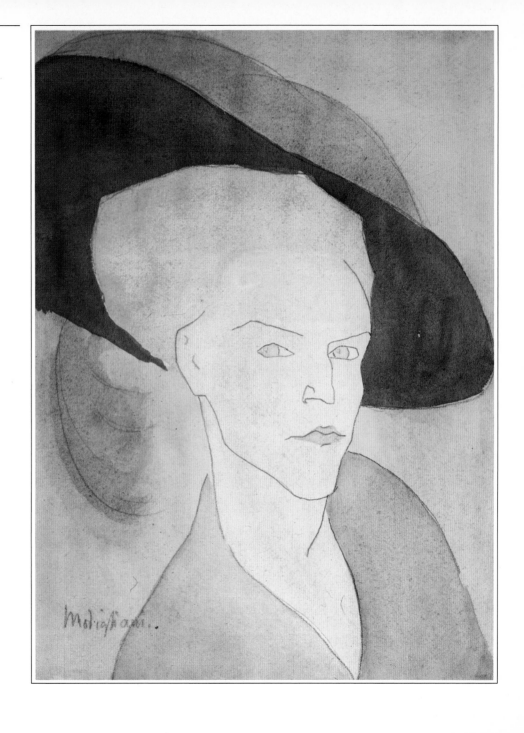

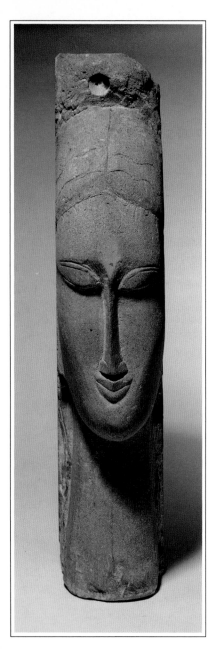

◁ **Head** c.1911

Stone

IT IS POSSIBLE that a visit to Rome in 1901, when he was just 17, followed by a period of study in Florence in 1902, sowed in Modigliani's mind the seeds of a desire to become a sculptor. In Rome he had been surrounded by the remains of ancient architecture and sculpture; in Florence, among the Renaissance artists he studied most closely was the sculptor Tino di Camaino, while he made special visits to the quarries at Pietrasanta and Carrara, from which had come Michelangelo's marble.

Although nothing survives of any early sculpture Modigliani may have done, the ambition to become a sculptor had taken root by the time he was 18, and when he arrived in Paris in 1906, he was already considering himself a sculptor as much as a painter. By the time he produced this finely carved head, with its suggestion of Chinese art, Modigliani had proved his ability to confer a marvellous variety of expression and characterisation on his sculpture.

> **Head** c.1911-13

tone

THE ARCHITECTURAL element, present in much of Modigliani's sculpture, is very much to the fore in this slender, even elegant carving. Here is the typical column-like shape and the flattened top of the head, as though this is intended as a caryatid, part of some great architectural scheme the artist had in his mind. In fact, Modigliani was never to complete any major sculptural work. The nearest he came to it was his group of seven stone heads, called *Heads - a decorative ensemble*, exhibited at the Salon d'Automne in Paris in 1912. By about 1915 Modligliani was finding it increasingly difficult to get stone to carve: the First World War, which had begun in 1914, had closed down many of the building sites from which Modigliani had taken (or stolen) his chunks of limestone. Poor physical health and the state of his tubercular lungs finally forced him to give up sculpture in favour of painting and drawing.

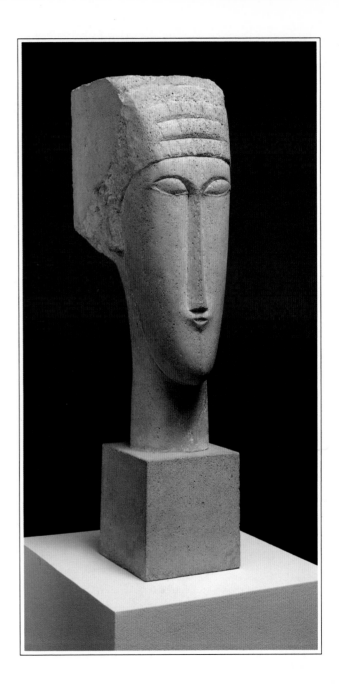

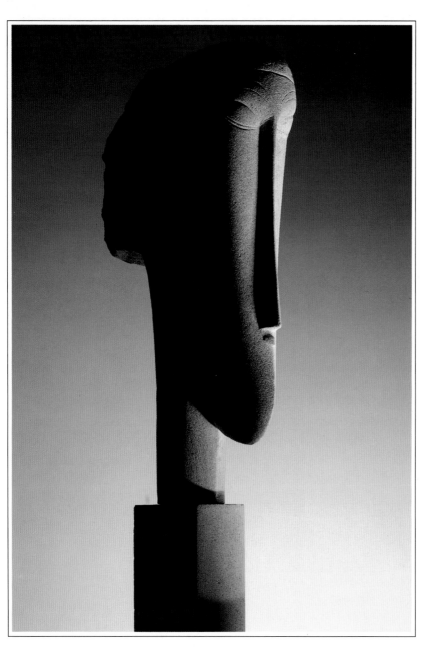

◁ **Head** c.1911-12

Stone

MODIGLIANI'S small output was not enough to put him among the foremost sculptors of the 'School of Paris' in the early years of the 20th century. Constantin Brancusi, whom Modigliani painted at least once and who was a great influence on the young Italian, guiding him towards an awareness of the sculpture of non-European civilizations, is considered to be the leading sculptor of the period, with Rodin's enormous presence still strongly felt. Even so, Modigliani's contribution to early 20th century sculpture was considerable and is typified by this stone head. The elongated form and strongly stylised features, apparently inspired by the primitive art of ancient Greece, or perhaps that of west Africa, is typical of Modigliani's sculptured heads. Works such as this showed how modern artists could harness the work of much older artists in virtually any tradition to say something new and relevant to the modern world.

Seated Female Nude c.1913

Blue chalk

THE LARGE GROUP of drawings of women with their arms above their heads, in the classical sculpture attitude of caryatids (female figures used as supporting columns in architecture), are among Modigliani's most beautiful works. The drawings were done, usually on large sheets of paper, in pencil, chalk, crayon and watercolour. Modigliani did more than one version of this particular pose, including one in a rose-coloured watercolour. Although the drawing suggests that Modigliani was doing preliminary sketches for sculpture, it would hardly have been possible, technically, to carry out the pose in stone. Critics tend to see this and similar drawings as attempts to evoke the spirit of the art of the period, including sculpture, rather than produce practical ideas to be rendered in stone.

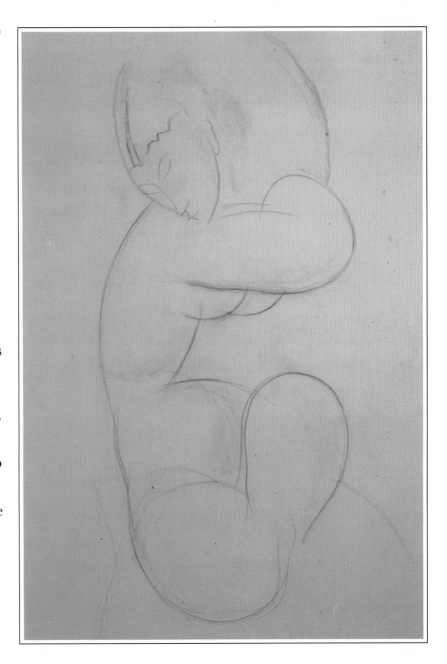

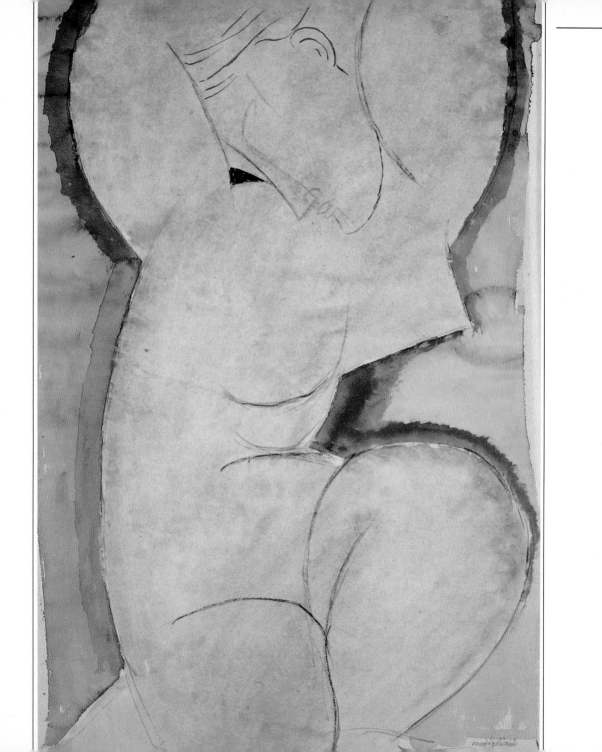

◁ **Caryatid** c.1913-14

Pencil and watercolour

F THE ELONGATED line of the *Seated Female Nude* (see page 13) suggests the influence of the sculptor Brancusi, this drawing seems more nearly attuned to the art of contemporary painters like Pablo Picasso, as well as to Modigliani's own work as a painter. In some ways, it provides a bridge between the work of Modigliani the sculptor and Modigliani the painter: the elongated, sharply defined nose could have come from one of the artist's sculpted heads, while the pose of the body suggests a painter's more sensual awareness of the warm flesh and the curved limbs of the female form.

▷ **Seated Nude** 1914

Pencil and watercolour

FOR THIS ASSURED STUDY, giving rein to his love of line, Modigliani has set aside the architectural caryatid pose which dominated so much of his work of this period and has chosen to put his model into a more artistically conventional nude pose. Although he has retained the sharply defined nose and one pointed breast of the *Caryatid* watercolour (see pages 14-15), he has allowed himself to demonstrate that he is fully aware of the infinite variations of shape, tone and texture to be found in the female form. Thus, the drawing represents another step in Modigliani's transition from an artistic life centred almost exclusively on sculpture to one in which painting would be the dominant interest.

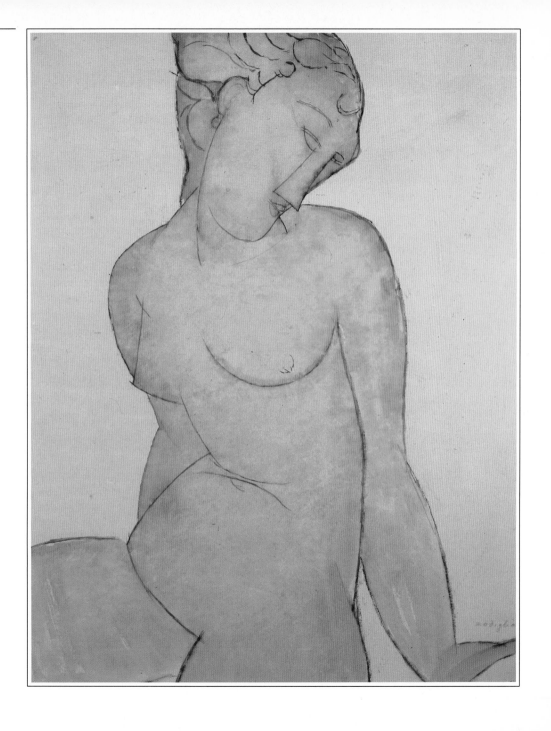

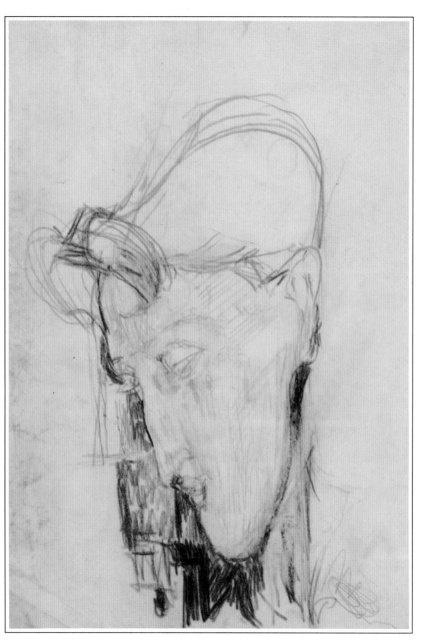

◁ **Study for Portrait of Frank Haviland** 1914

Pencil

MODIGLIANI'S STUDY OF Frank Burty Haviland, a wealthy young would-be artist and private patron of the young Paris artists of the time, was done in a period of transition for the artist. Having failed to sell any of his sculpture, while the war prevented his allowance from Italy arriving regularly, if at all, Modigliani was forced to draw people in cafés for cash. Eventually, having virtually abandoned sculpture, Modigliani began to experiment with new techniques in his painting. The portrait of Frank Haviland, like another one done in 1914, that of the Mexican artist Diego Rivera (see page 19), was done in a semi-divisionist style, drawing on the technique devised by Georges Seurat, and with Fauve colours. This preliminary drawing, while it could not indicate the dots of pure colour in which much of the oil painting was carried out, provided the basis for the pose of the head and the detail of the hair in the finished portrait

> **Diego Rivera** c.1914

Pen and ink

THE OUTSIZE, ebullient and convivial Diego Rivera, who was to become Mexico's best-known 20th century artist, was one of Modigliani's closest friends and his companion on many a drunken sortie through the bars and cafés of war-time Paris. Modigliani did many drawings and paintings of Rivera, most of them emphasising his Rabelaisian quality. This pen and ink study, which appears to have been a preliminary drawing for a large oil painting, also done in 1914, bears an extraordinary affinity with one of the very few square-shaped – as distinct from columnar – sculptures that Modigliani produced. It is also quite free of the elongated style Modigliani employed for most of his portraits of this period: it is the real round-faced, small-featured Rivera looking out at us from the drawing.

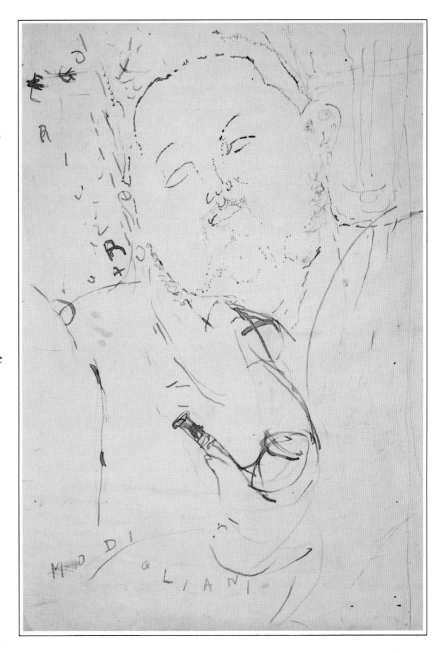

Detail

▷ **Pierrot (Self-portrait)** 1915

Oil on paper

THIS PICTURE, labelled *Pierrot* by Modigliani, has often been taken as a self-portrait. While it is a strangely androgynous view of himself, the face and neck stippled with points of soft and delicate rose and sage-grey colours, it is also typical of Modigliani's portraits of this period. Although he was very economical with the 'props' which made up the backgrounds of his portraits, Modigliani was still happy at this time to give his portraits a certain liveliness by adding little personal details – earrings or brooches, perhaps a lace collar or a little feather-trimmed hat for his women subjects, a bowler hat or neatly knotted tie for his men. Here, Pierrot has around his greatly elongated neck – a legacy of the sculpture Modigliani had been working on so recently – the frilled collar of a clown or harlequin.

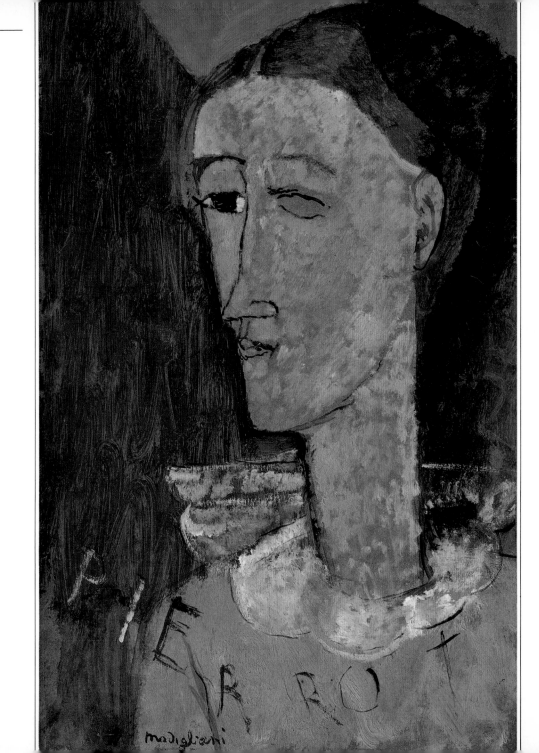

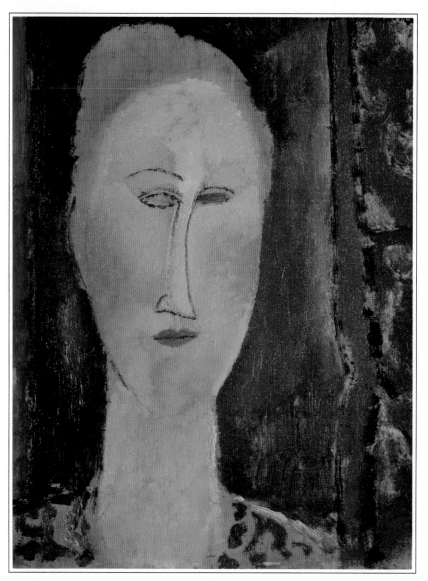

◁ **Tête de Femme** c.1915

Oil on board

MODIGLIANI WOULD SEEM to be painting a type, as much as a real person, here. The portrait, set in a strongly patterned border created from the woman's dress and the curtain edge in front of her left shoulder, is clear-cut, almost harsh, in its depiction of the face. The small, close-set eyes and the little mouth, connected visually by the long pointed nose, suggest a wary, even a rather suspicious, nature. Stylistically, the portrait shares certain characteristics with others of 1915, including one of Henri Laurens and one, called *Raymond,* which is thought to be a portrait of a youthful Raymond Radiguet, author of *Le diable au corps.* In all three portraits Modigliani has chosen virtually to omit the left eyebrow and reduce the left eye to an inward-looking patch of colour.

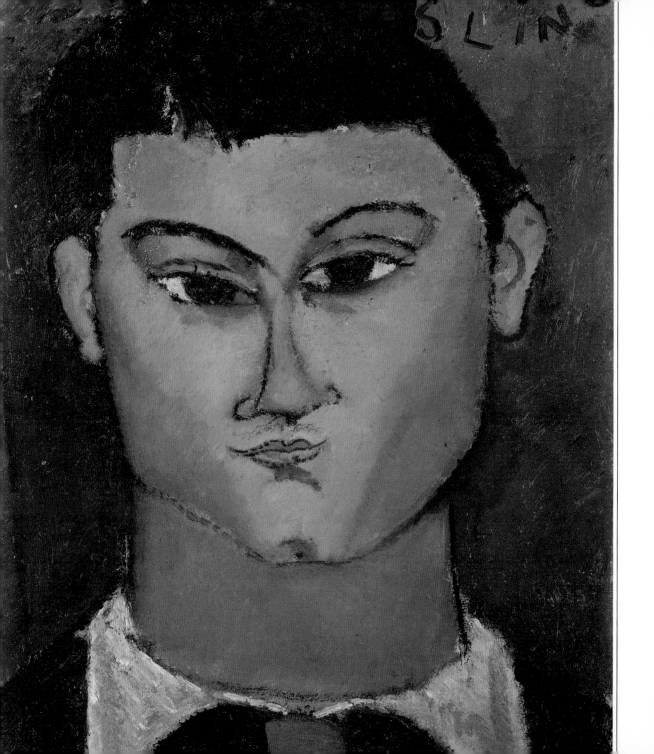

Portrait of Moïse Kisling 1915

Oil on canvas

◁ *Previous page 23*

ONE OF MODIGLIANI'S close friends in Paris was the painter Moïse Kisling, one of a number of non-French, Jewish artists, including Soutine, Jacques Lipchitz and Modigliani himself, who made up a distinct group in the cafés of artistic Paris. Modigliani's drawings and oil paintings of Kisling are invariably direct, depicting a straightforward, generous man. They reflect the artist's relationship with Kisling, who was generally helpful towards Modigliani, letting him use his studio and even his painting materials. The two men are known to have painted together on occasion, notably when both artists did portraits of the French intellectual, Jean Cocteau. About the time this portrait was painted, Kisling chose to play his part in the War by joining the Foreign Legion; he was fortunate to survive, returning to Paris at the war's end.

▷ Chaïm Soutine 1915

Oil on canvas

BORN IN MINSK into poverty and neglect in a Jewish ghetto, Chaïm Soutine managed to make his way to Paris before he was 20. Despite the great difference in their temperaments – Soutine the wild romantic who would become a leading Expressionist and Modigliani the classicist – the two were soon close friends and colleagues. To Modigliani must go most of the credit for turning the extraordinarily inarticulate, dirty and crude young Soutine into a socially acceptable person: it was Modigliani who taught Soutine how to hold a knife and fork and use a handkerchief. At the same time, Modigliani clearly accepted Soutine's artistic talent: there is no sign of condescension in this portrait which is, rather, an affectionate study of the young artist.

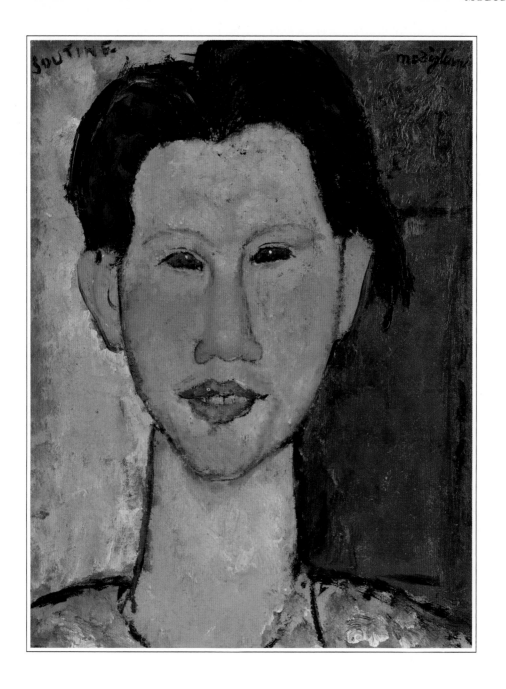

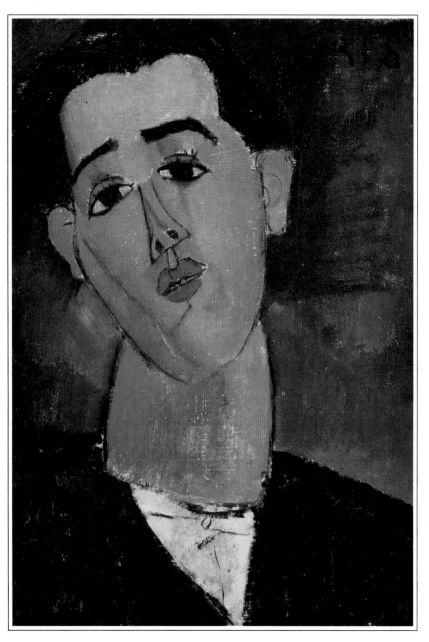

◁ **Portrait of Juan Gris** 1915

Oil on canvas

JUAN GRIS, WHOSE real name was Jose Victoriano Gonzales, was one of several painters from Spain (Picasso was another) working in Paris at this time. He was deeply involved in painting in the analytical form of Cubism currently being followed in Paris, but with a refinement and originality that has assured him a major part in the history of modern painting. The rather effeminate pose Modigliani has given to his portrait of Juan Gris has allowed commentators to infer that he did not greatly care for the Spanish painter. True, Modigliani emphasises his subject's large, long-lashed eyes and sets the thin face on a thick, fleshy neck. At the same time, Modigliani is clearly painting someone who is more than just a passing face. Gris, remaining in Paris in 1915 despite the war, was part of Modigliani's close circle and as such an obvious subject for a portrait.

▷ **La Femme en Bleu** c.1915

Oil on canvas

THIS UNFINISHED STUDY of a woman shows that Modigliani was aware of Paul Cézanne's painting methods, for the painting's tone values are carefully considered and anchored by the precise lines of the drawing, in the way of a late Cézanne. In his more mature paintings, Modigliani concealed the strong structural foundation of his work, making his paintings appear effortlessly elegant.

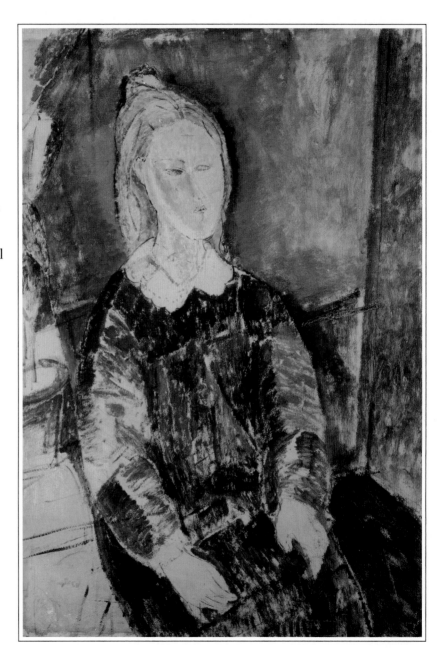

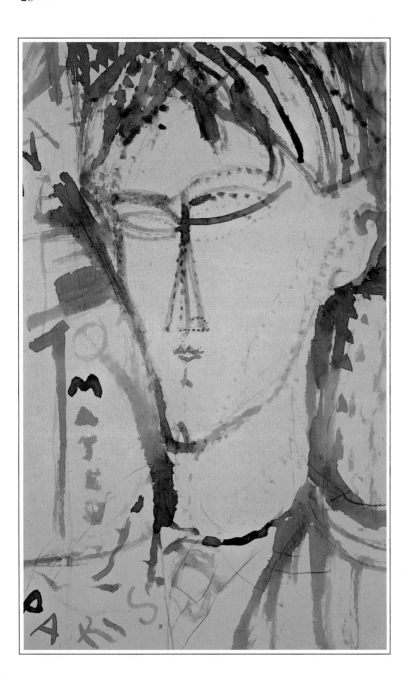

◁ **Portrait of Mateo Alegria**
1915

Brush and ink wash

THIS BRUSH AND INK wash
drawing is typical of a group of
apparently experimental
portraits Modigliani worked
on for some months in 1915,
using various media, including
gouache and oil. Although he
was by now firmly committed
to drawing and painting,
rather than to sculpture, the
pictures suggest that
Modigliani was not yet firmly
committed to a specific way of
painting. All the pictures in
the group of which the *Mateo*
drawing is one, were painted
rather tentatively, with dots,
dashes and short lines of paint
being used to build up the
portrait. The pictures are in
strong contrast to the fluid,
flowing lines of drawings like
the pink-coloured *Seated Nude*
(see page 17).

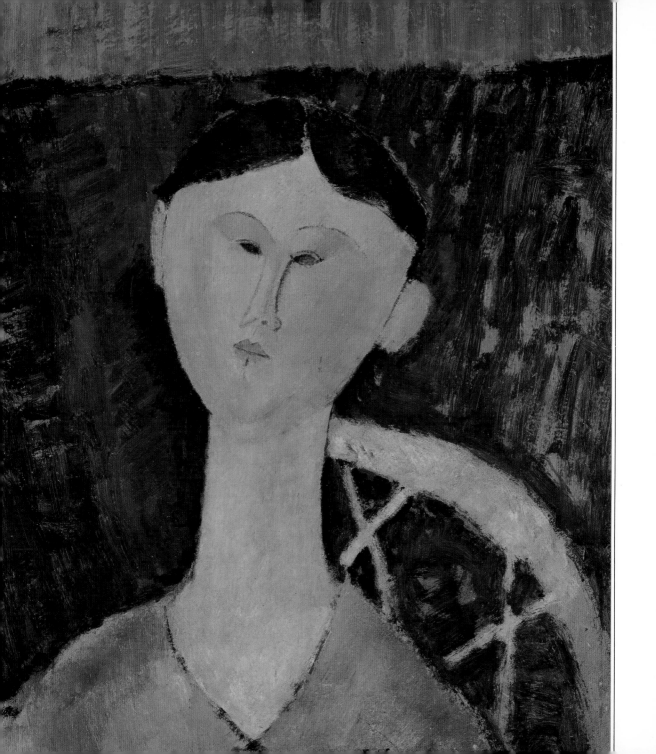

Portrait of Mrs Hastings 1915

Oil on cardboard

◁ *Previous page 29*

BEATRICE HASTINGS, a South African-born English poet and writer, came to Paris in 1914 to write about the art scene there for the avant-garde review, *The New Age*, which was published in London. She met Modigliani shortly after her arrival in Paris and had a close and often stormy relationship with him for two years, during at least part of which they lived together in a house in Montmartre. Although Modigliani had had affairs with other women, Beatrice Hastings was the first serious emotional and sexual relationship in his life, and would seem to have played a significant part in his development as an artist. This simple portrait, its outline and flat modelling suggesting that Modigliani was looking back to his sculptural ideal as he painted it, is perhaps the least characterful of the 14 paintings Modigliani did of her.

▷ **Madam Pompadour** 1915

Oil on canvas

THIS LIVELY PAINTING is thought to be a portrait of Beatrice Hastings, proudly showing off a new hat. Beatrice is known to have enjoyed having fine clothes to parade in, and it is very likely that the picture, with its label painted clearly in English on it, was Modigliani's way of poking gentle fun at her: she may think that her new hat gives her the air of a great lady, but he is likening her to a courtesan and king's mistress, while her hat has a distinctly carnival air about it.

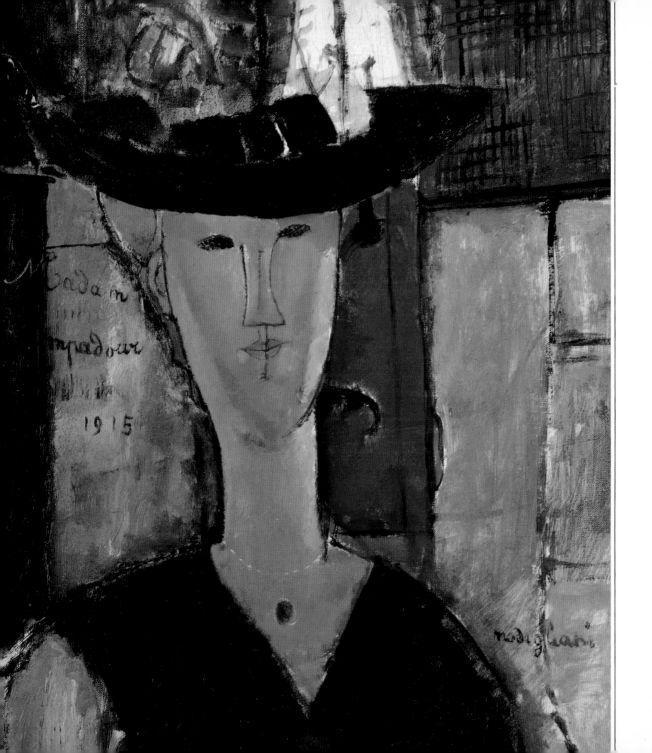

Madam
mpadour
1915

modigliani

Detail

▷ **Bride and Groom (The Couple)** 1915-16

Oil on canvas

BY THE TIME he painted this double portrait Modigliani had developed a 'formula' for painting faces. Apparently influenced to a degree by the ideas of the Cubists and by African art, a typical Modigliani 'face' of this period would emphasise the central positioning of eyes – usually small, almond-shaped and blank – elongated nose, often defined by a straight line on one side and a curved line on the other and a small, button mouth, often with a line through it. Despite using his 'formula' to paint both the faces in this portrait, Modigliani has still been able to give his portraits a splendid characterisation, conveying brilliantly the essential inanity and shallowness of both sitters. By the time he painted this picture, Modigliani had a dealer, Paul Guillaume, who was no doubt encouraging him to paint saleable portraits.

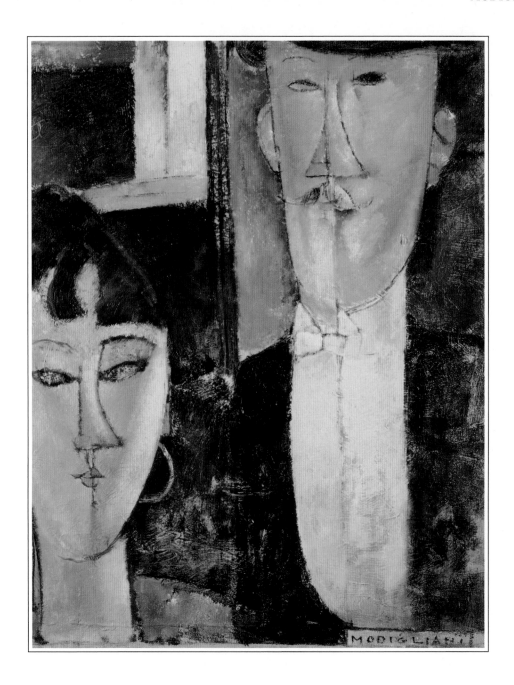

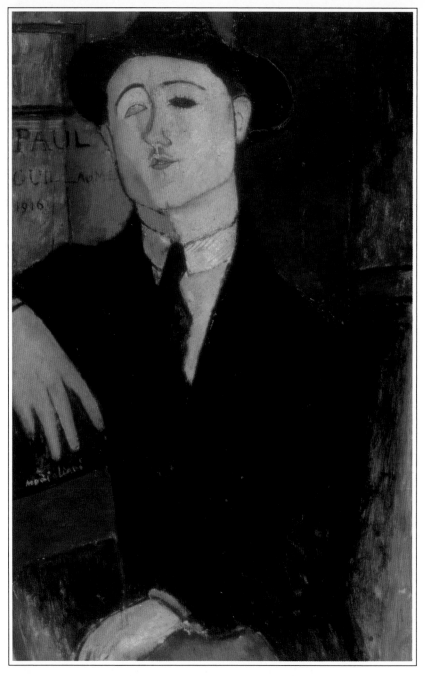

◁ **Paul Guillaume Seated**
1916

Oil on canvas

MODIGLIANI PAINTED his first
professional dealer, Paul
Guillaume, several times.
Guillaume, who specialised in
African art when Modigliani
first came into contact with
him, quickly recognized the
artist's abilities, though he
feared he was not 'commercial'
enough, and did much to push
his work in 1915-16 and again
in 1918. As all his portraits of
the dealer show, however,
Modigliani did not quite trust
Paul Guillaume. True, the
dealer looks elegant and well-
dressed enough in this
portrait, but there is
something a little too precious
about the neat collar and the
close-clipped little moustache
above the small, red mouth.
Clearly, Modigliani does not
feel the expansive warmth
towards Paul Guillaume that
he expressed in his paintings
of friends like Chaïm Soutine
and Max Jacob.

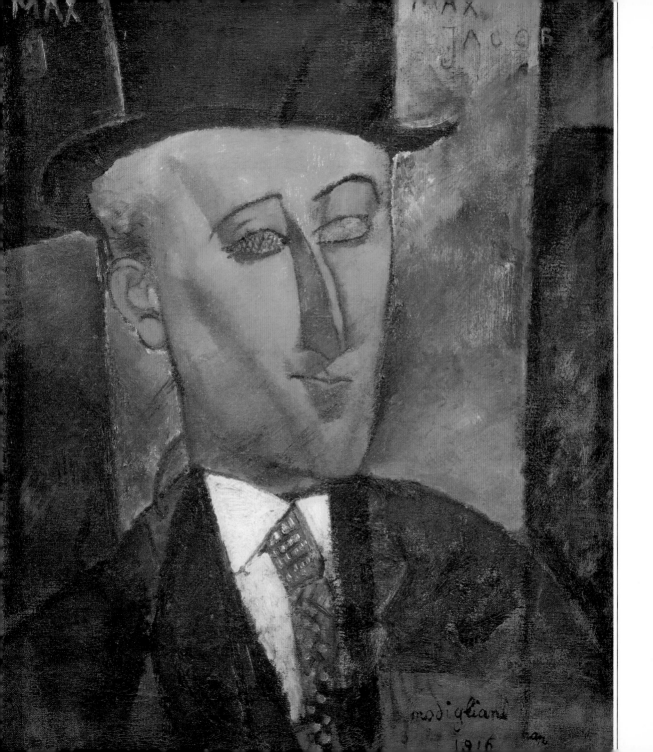

Max Jacob 1916

Oil on canvas

◁ *Previous page 35*

MAX JACOB, A MAN OF considerable intellectual gifts, was a notable figure in artistic Paris, even sharing a room with Picasso when he first came to live in the city. He was also a boon companion of Modigliani in war-time Montparnasse, the two often enlivening evenings in cafés by declaiming poetry and making speeches. Where Modigliani was often drunk, often shabbily dressed in filthy clothes – which he was not beyond tearing off in public when the mood took him – Jacob was generally restrained and much more socially acceptable. That Modigliani felt a certain affection for Jacob is evident in his two oil paintings of him and in the many drawings; here Modigliani gives us Jacob the *boulevardier* -- elegantly dressed, refined, but with a certain quiet humour about him. The cross-hatching which Modigliani sometimes put in the eyes of his portraits at this time – 'to filter the light', as he explained to a friend at the time – is very evident in this portrait of Max Jacob.

▷ The Sculptor Lipchitz and His Wife 1916

Oil on canvas

JACQUES (CHAIM) LIPCHITZ was another Jewish refugee from the Baltic making his way in the art world centred on Paris when Modigliani got to know him. Lipchitz was a sculptor and thus moved in the same small circle as Modigliani in the years before the First World War. Lipchitz was a very fine sculptor, who would eventually find fame in America, where he fled to escape the German Occupation of France. By the time this double portrait was commissioned by the sculptor to mark his marriage, he was already a much more established and successful artist than Modigliani – a fact which may have annoyed the latter, who has suggested a certain bourgeois respectability, even self-satisfaction, about his sitters here. Since Lipchitz was paying Modigliani by the hour for the picture, and had commissioned the double portrait because he thought the artist would have to spend more time on it, this argues a certain ingratitude on Modigliani's part.

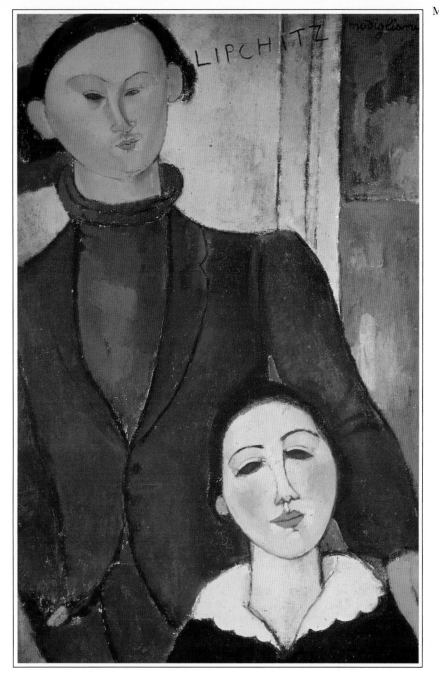

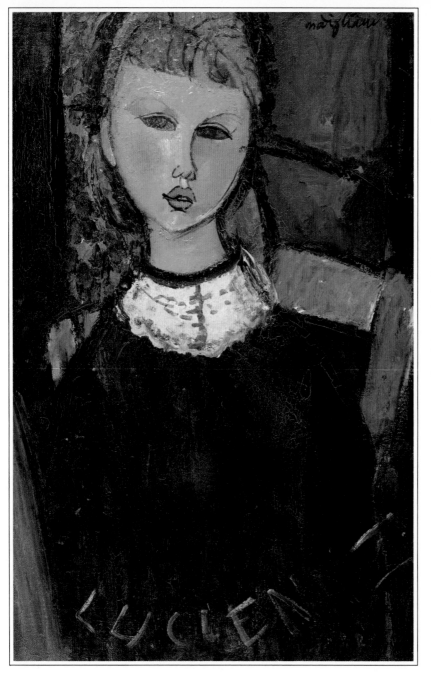

◁ **Lucienne** c.1916-17

Oil on canvas

APPARENTLY RAPIDLY painted, with much of the background scrubbed in, this is yet a wonderfully effective portrait, depicting the charming innocence of girlhood without any sugary sentiment. Modigliani is here abandoning the 'formula' he had devised for his portraits and moving towards a more natural, realistic approach. The use of the lace collar to help frame the head and set it apart from the black, sloping-shouldered body and dark background colours is very effective.

> **Chaïm Soutine** 1917

Oil on canvas

CHAÏM SOUTINE LIKED to wear
Modigliani's cast-off shirts; he
said it gave him confidence
and the feeling that he might
even become Modigliani.
Certainly, this is a more
mature man, more sure of his
way in the world, than the boy
Modigliani painted in 1915
(see page 25). It may even be
one of Modigliani's shirts
Soutine is wearing here: a hint
of the friendship between the
two, perhaps, like the nearly-
empty wine glass on the table
beside Soutine. Modigliani has
been careful to paint a true
likeness of his friend here,
setting aside his usual fine,
sculpture-like noses and small
mouths to show Soutine's
much fleshier nose and full
mouth as they really were.

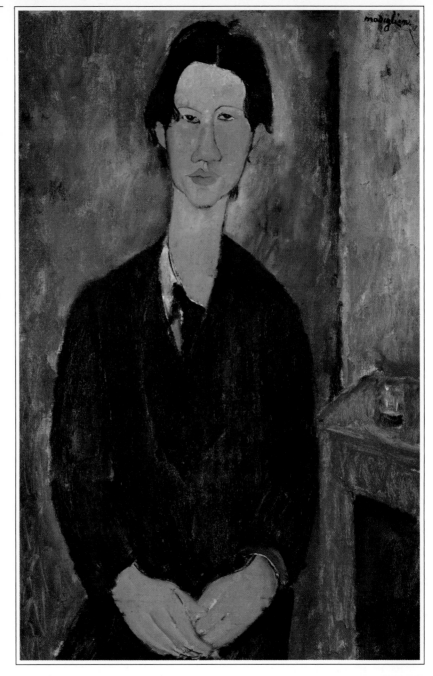

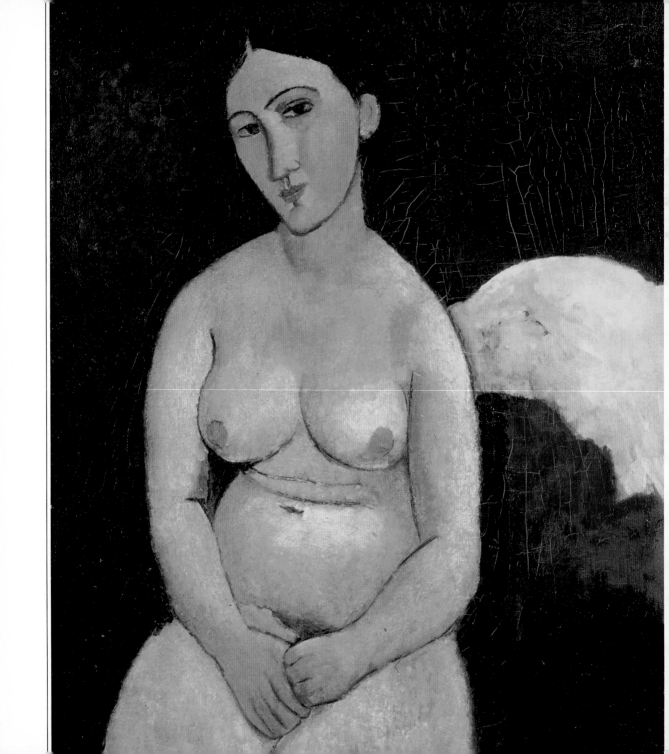

◁ **Seated Nude** 1917

Oil on canvas

MODIGLIANI BEGAN IN 1916 a great series of oil paintings of the nude (as distinct from his earlier nudes, many of them drawings and watercolours, which stemmed largely from his sculptural work) with a group of pictures of women stretched out on a sofa. Although some commentators have suggested that his models were prostitutes from the Paris streets, it would seem that in fact he used either girls from outside his own world or, when he could afford them, professional models. The face and full-breasted body of this seated nude are very similar to those of one of the reclining nudes of 1916, suggesting that Modigliani had recalled an early model for the picture. Apart from one possible drawing, there are no firmly identifiable nude studies of Beatrice Hastings, for instance, despite the fact that they lived together for a long period, nor did Modigliani do nude paintings of his close women friends.

Reclining Nude, One Arm on Her Forehead 1917

Oil on canvas

▷ *Overleaf pages 42-43*

THE FULL, RIPE, almost Rubensesque beauty of the *Seated Nude* has given way in this painting to something much more in keeping with 20th century ideas of erotic female beauty. Both setting and pose are simple, allowing the viewer's full attention to concentrate on the deliberately provocative pose in which the artist has placed his model. She herself is looking away to one side, as if distancing herself from the artist and his work. As with many of Modigliani's nudes, the woman is allowed to be independent, to be emancipated, as it were. She does not stare out of the canvas, offering herself like some courtesan or prostitute – which would, of course, have made her more acceptable to ideas of public decency at the time.

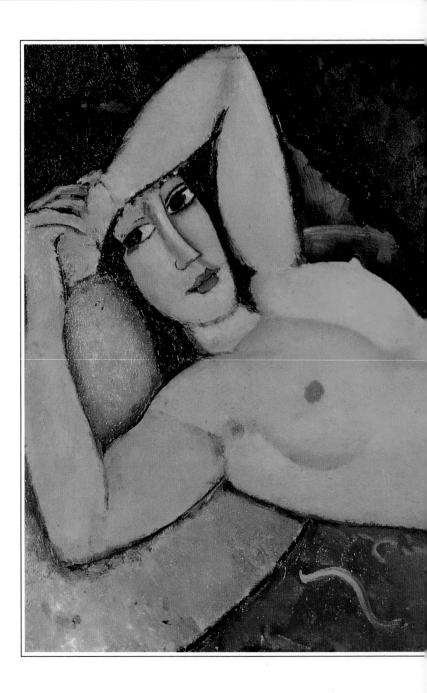

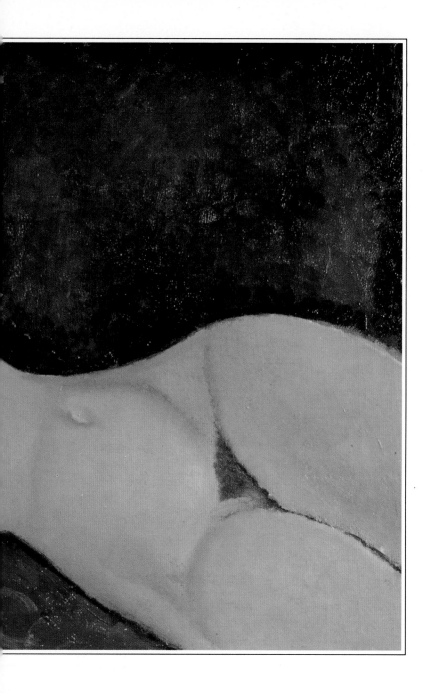

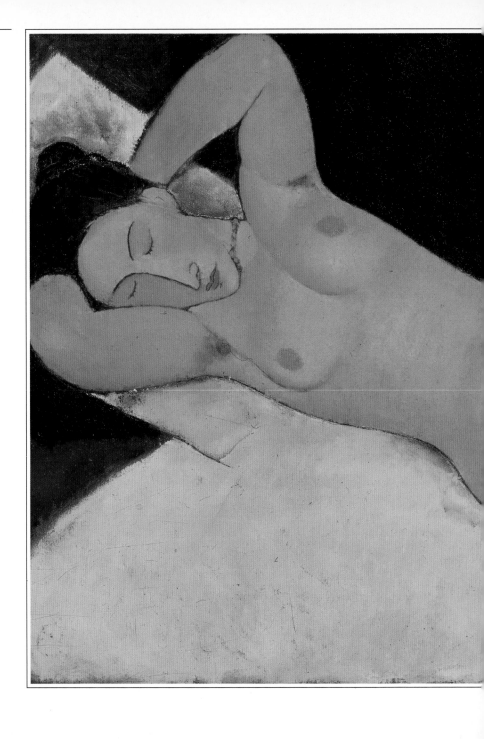

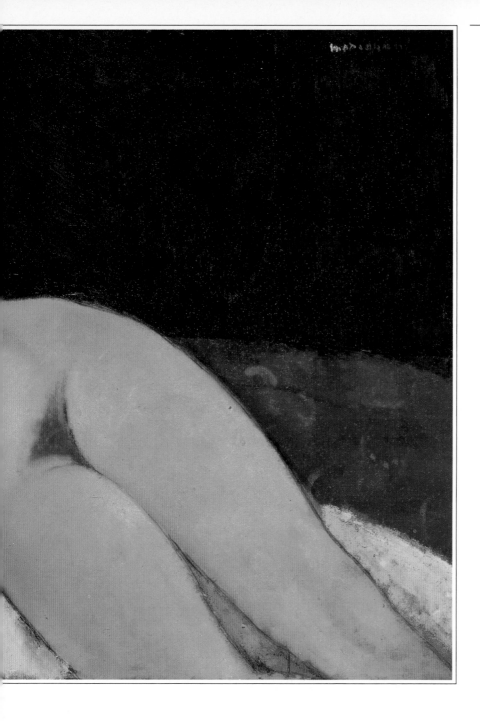

> **Seated Nude with a Shirt**
1917

Oil on canvas

IN HIS BOOK, *The Nude in Modern Painting*, Francis Carco wrote of Modigliani's nudes that 'their proud integrity shines out, needing no illumination other than itself, bathed in their own mysterious, impenetrable glow…'. Like Botticelli, his Renaissance predecessor, whose skill with line he mirrored, Modigliani had a genius for understanding how the movement of a line, its straights and curves and thicknesses, could be used to describe depth and volume.

Nude with Necklace 1917

Oil on canvas

◁ *Prevous pages 44-45*

IT WAS THE SHOCKINGLY direct, full frontal pose of nudes like this, set against a simple, dark background, and painted in the warm, dark tones that became Modigliani's hallmark, that caused Modigliani's first – and last – one-man exhibition, at the Berthe Weill Gallery in Paris in December 1917 to be closed down on the Private Viewing Day: a throng of people gawping at the large nude painting in the window of the gallery in the rue Taitbout drew the attention of a police officer from the police station across the street and he ordered all the paintings to be taken down. Neither Modigliani nor Berthe Weill had any redress. Some years after the Second World War, the Solomon R. Guggenheim Museum in New York, which owns this painting, was asked by the New York postal authorities to withdraw from sale their postcard reproductions of it.

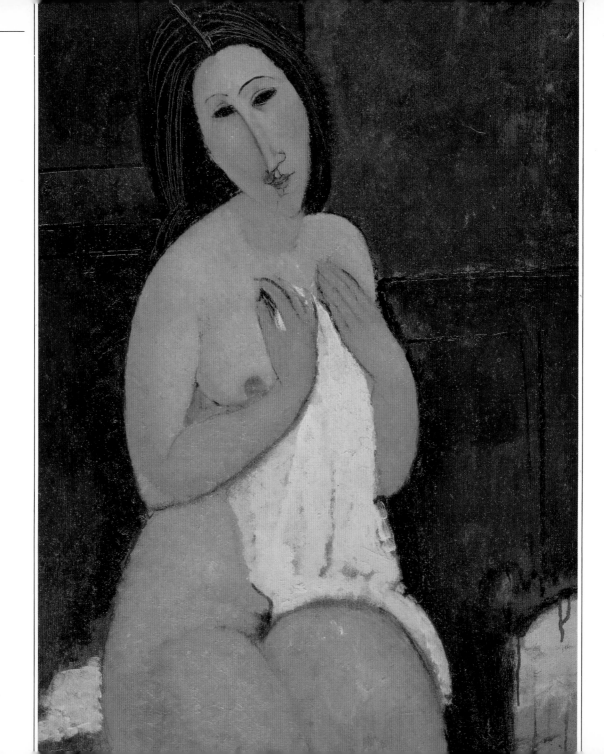

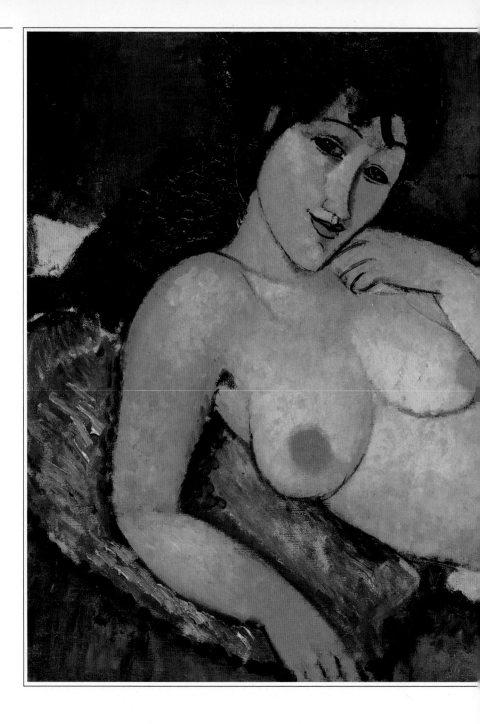

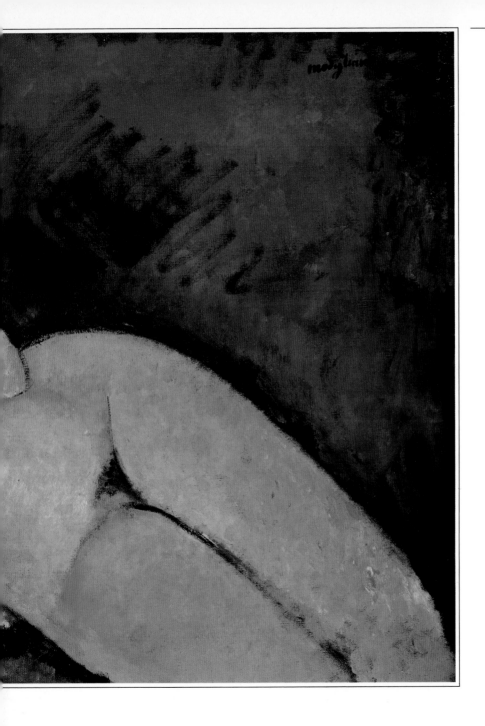

▷ **Leopold Zborowski** 1917

Oil on canvas

LEOPOLD ZBOROWSKI, known a
'Zbo', was a Polish poet living
in wartime exile in Paris who
greatly admired Modigliani's
work. In 1916 he took over
from Paul Guillaume the
arduous business of being his
dealer. From now until the en
of his life, Modigliani had
Zborowski as his only source o
funds, the young Pole
devoting much of his time and
energy to promoting and
selling the Italian's work and
to finding him models and
studios. Modigliani was to do
six oil portraits of Leopold
Zborowski, several of his wife,
Hanka, and many drawings of
them both.

Nude on a Blue Cushion 1917

Oil on canvas

◁ *Previous pages 48-49*

THROUGH THE USE of a blue
cushion and dark-coloured sofa
and in the reclining pose of the
model, this nude is repeating
previous paintings by
Modigliani. What gives it
uniqueness is Modigliani's
insistence on painting the
woman as an individual: the
face here is that of a real
woman, distinctly different
from other models in other
nude paintings by him. As in
others of his paintings of
women in this reclining pose,
Modigliani has not drawn in
the whole length of the legs
and has painted rather
cursorily the part of the thighs
that he has shown. His
attention has been given to
depicting in wonderful detail
the full breasts and their
delicate changes in shading and
tone. The overall effect is
disturbingly erotic.

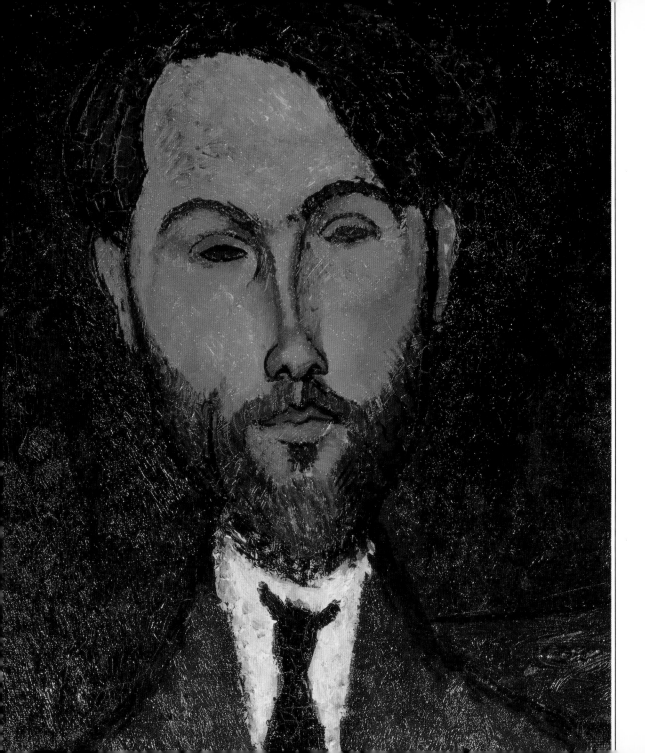

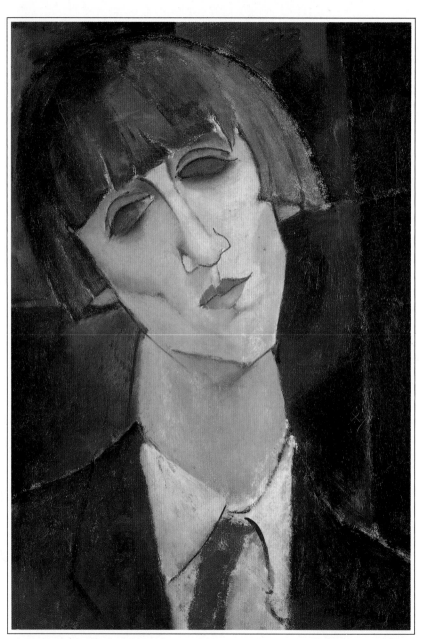

◁ **Madame Kisling** 1917

Oil on canvas

RENÉE KISLING, WIFE OF Modigliani's friend and fellow artist, Moïse Kisling, is said to have treated Modigliani like a brother. The Kislings shared a studio for a time with Modigliani, often joining him in parties at such well-known haunts as the Carrefour Vavin. Renée Kisling was well-known in Paris for the eccentricity of her dress and hairstyle, which Modigliani faithfully reproduced in at least two portraits, both of which strongly emphasised the artist's graphic skill as much as his use of oil paint. In this one, the definition of the line is more concentrated than other portraits, especially in the jaw line and hair.

> **Portrait of Thora Klinchlowstrom** c.1917-18

Oil on canvas

AMONG LEOPOLD ZBOROWSKI'S many self-imposed tasks as Modigliani's dealer and agent was the acquiring of portrait commissions from businessmen, wealthy refugees from the war in Europe, or, with luck, prominent personalities, whose portraits displayed, perhaps, in a Paris gallery, would attract attention to Modigliani's genius as a portrait painter. It is possible that Thora Klinchlowstrom was the wife, daughter or sister of such a person. This portrait is moving towards Modigliani's mature style, based on marvellous fluidity of line, smooth paintwork and an elegant style.

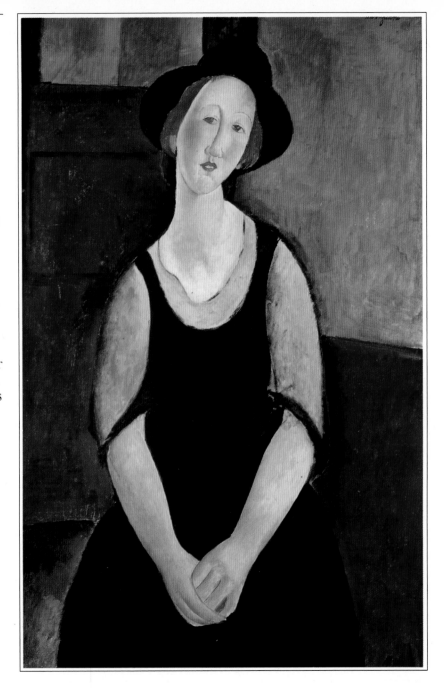

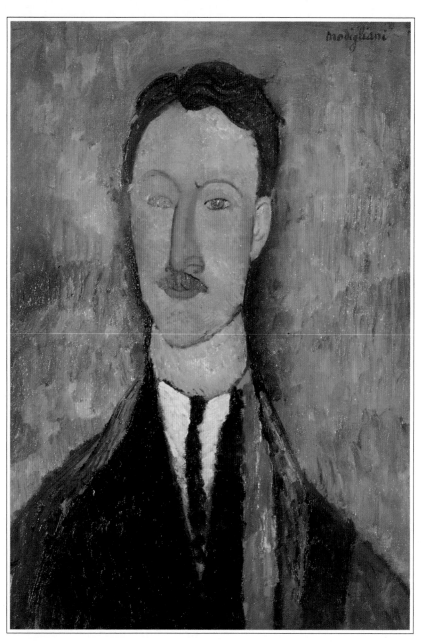

◁ **Portrait of Léopold Survage**
1917-18

Oil on canvas

LÉOPOLD SURVAGE (or Sturzvage, to give him his Russian name) was an engraver who became one of Modigliani's friends and drinking companions. When Modigliani was persuaded to make a stay in the South of France for the good of his health early in 1918, he was pleased to meet up with Survage because they could go out on the town together. Since Modigliani did not care for the bright light and warm air of the South of France, he did not paint his friends there, and this portrait of Survage is thought to have been done in Paris before the trip south. It is one of Modigliani's last really characterful portraits, with the sitter's personality brilliantly depicted in a picture that is full of movement.

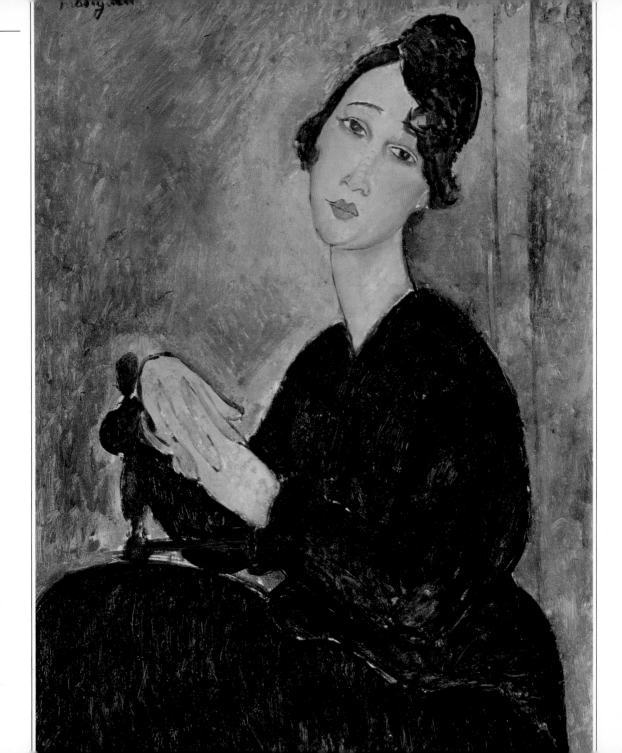

▷ **Boy in a Blue Jacket** 1918

Oil on canvas

MODIGLIANI AND THE CLOSE companion of his last years, Jeanne Hébuterne, spent much of 1918 on the Côte d'Azur, in Nice and Cagnes, largely for the good of Modigliani's shattered constitution. Although Modigliani painted four landscapes while he was in Cagnes, he continued to paint mostly pictures of people, often with a lighter palette than he had been using in Paris. The people were seldom his friends, Modigliani preferring to paint in the south of France people unknown to him – servants, children, people doing everyday things. This portrait of a boy, the colour of his jacket reflected in his eyes, is typical of the artist's portrait style at this time, the elongated line of the head being matched by the narrow, sloping line of the shoulders.

Portrait of Dedie 1918

Oil on canvas

◁ *Prevous page 55*

ODETTE DEDIE HAYDEN was the wife of a Polish painter in Paris, Henry Hayden. Modigliani did two portraits of her in 1918-19, both of them showing her seated with a certain stylish elegance, her pretty hands prominently displayed. This one, the first of the pair, is unusual in that the artist has posed his sitter with her body in a semi-profile position, rather than facing the canvas straight on. The pose has allowed him to show the neck in semi-profile, too – and to give a hint of Madame Hayden's slight double chin.

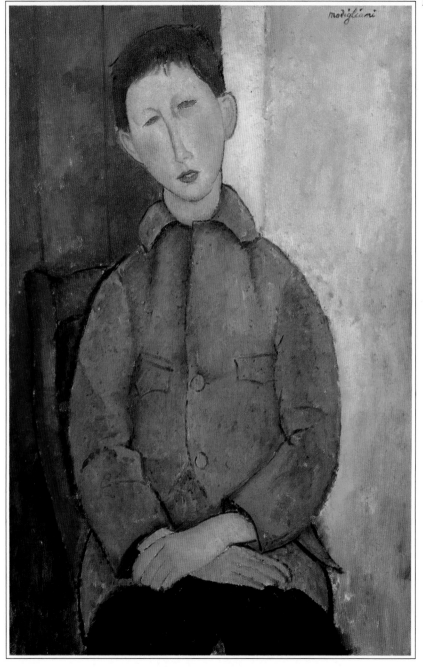

▷ **Jeanne Hébuterne** 1918

Oil on canvas

JEANNE HÉBUTERNE, a young pupil at the Académie Colarossi in Paris came into Modigliani's life early in 1917. His early portraits of her were in his 'society portrait' mode – Jeanne with a necklace, Jeanne wearing a small black hat, Jeanne wearing a large black hat – but as their intimacy grew so his portraits became more intimate, more revealing of the real young woman. From all accounts, she was a quiet, submissive girl who adored him totally, making no attempt to 'reform his lifestyle or his drinking and drug-taking habits. It is the quiet, loving girl who stares out of this portrait at the artist.

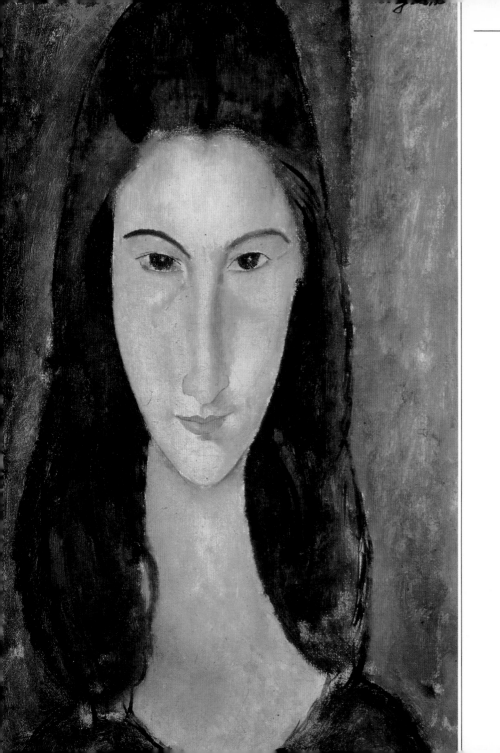

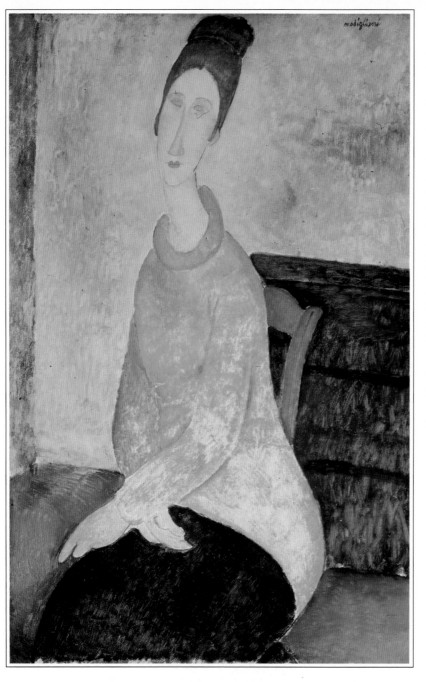

◁ **Jeanne Hébuterne in a Yellow Jumper** 1918

Oil on canvas

THIS IS JEANNE HÉBUTERNE given the lighter colour Modigliani used in portraits painted in the south of France. It is as if the bright sun and light, clear air of the south has been allowed to permeate his paintings. She is also pictured as a mature woman, rather than the girl of earlier portraits. It is probable that when this portrait was being painted, Jeanne was pregnant with her first child by Modigliani, a girl they called Giovanna, though she was registered as Jeanne Hébuterne, being born in Nice in November 1918.

The Beautiful Grocer 1918

Oil on canvas

VERY UNUSUALLY for Modigliani, he has allowed a hint of nature, or at least of an outdoor world, into this simplified, light-toned portrait, in which he has reduced the head and body of the shopgirl into a connecting group of oval shapes; head, neck, arms, torso. Despite the light colours in which most of the picture is painted, it is an austere work, with no leaf or twig being allowed to break the severe, flat outlines of the tree trunks and branches. The girl herself – surely Modigliani's title for his picture, *La Belle Epicière*, is meant ironically – seems lifeless, her stare fixed. It is a harsh, disquieting world Modigliani seems to be depicting here.

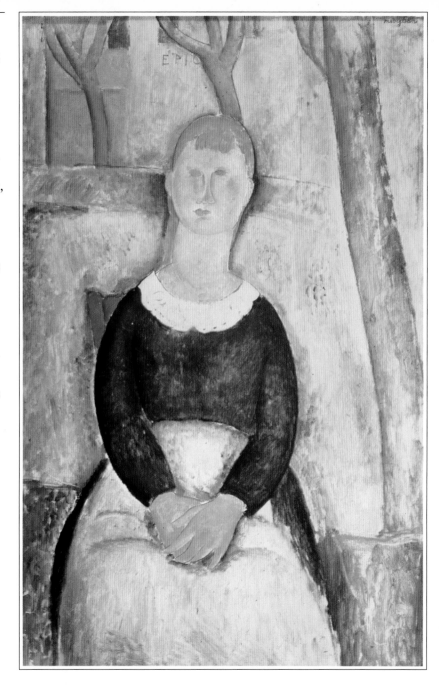

▷ **Girl with Pigtails** 1918

Oil on canvas

THIS LITTLE GIRL was the subject of at least two more pictures done by Modigliani during his time in the South of France. In two pictures she sits on a plain kitchen chair and wears the same pink, high-necked dress in all three. In one picture her pigtails are pushed up under a beret. All three pictures are painted indoors with the same wooden door, or piece of furniture in the background. During his 15 months away from Paris in 1918-19, Modigliani painted mostly unknown people and even, while sharing a studio in Cagnes with Soutine, attempted some landscapes. Despite his awareness of the work of Cézanne, who had lived and done much of his greatest work not far away in Aix, Modigliani never attempted still lifes, although critics have seen Cézanne's influence in the poses and colours of many of Modigliani's portraits of this period.

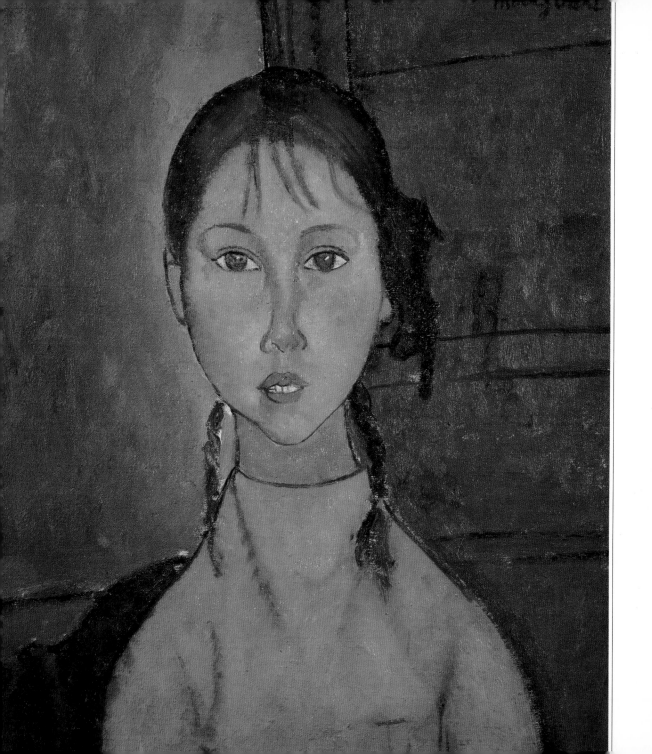

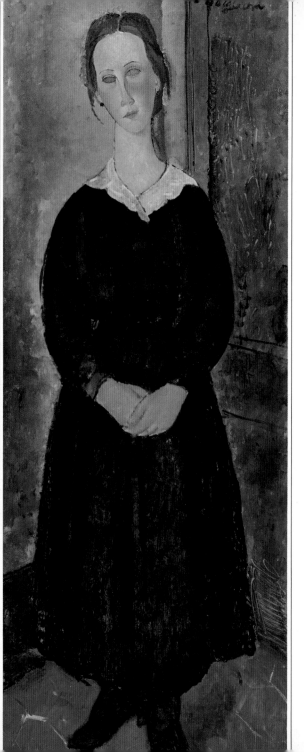

◁ **The Young Chambermaid**
1918

Oil on canvas

HERE IS ANOTHER local girl –
someone who is not a
professional model, but is
prepared to stand patiently
while the artist paints her
picture. A story told about this
picture is that Modigliani has
stood the girl 'in the corner'
for bringing him lemonade
when he had ordered wine.
The story may well be true,
though this was not the only
picture of this period in which
Modigliani stood his young
girl model in a corner of a
room in a quite specific
environment in which even
the tiled floor was painted in
detail: *Little Girl in Blue* used
virtually the same pose and
showed the same steady gaze.

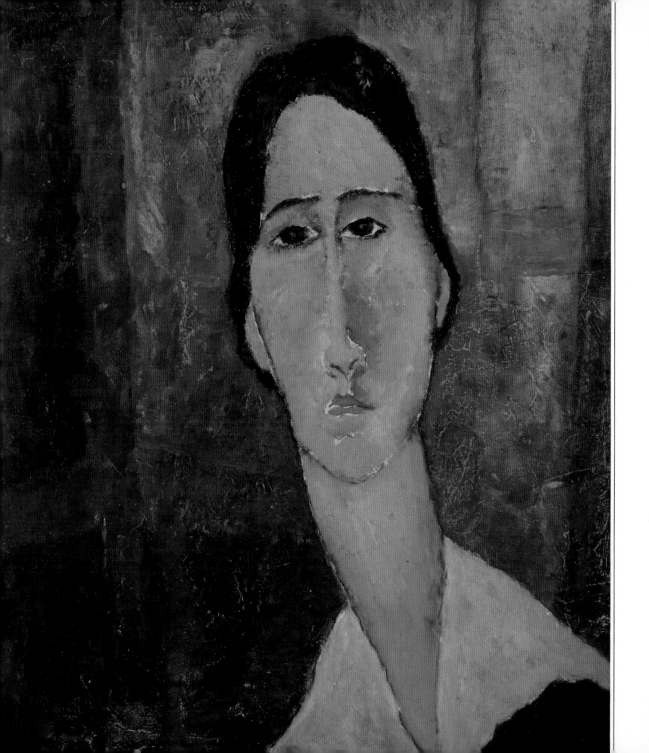

▷ **Gipsy Woman with Baby**
1918

Oil on canvas

MODIGLIANI ONCE REMARKED to Léopold Survage 'In order to work I need a living person before me'. In his best portrait the rapport Modigliani established between himself and his sitter is clear: however many times the artist has used the pose in other pictures, however familiar the treatment of the individual components of the face and body, the unique character of the sitter is clearly portrayed. It is probable that Modigliani felt a special affinity with this sensitively painted gipsy woman and her baby, for by this time, Modigliani was about to become a father himself. Although he was not married to Jeanne Hébuterne, he acknowledged her child as his from the moment of her birth and seems always to have felt a strong paternal concern for her.

Jeanne Hébuterne with White Collar c.1917-18

Oil on canvas

◁ *Previous age 65*

THE DARK BACKGROUND argues a pre-South of France date for this picture, yet the tired, almost lifeless expression suggests a later period, perhaps when Jeanne was pregnant with their first child in mid-1918. Artistically, this picture is interesting for its treatment of one of the major themes of Modigliani's portraits of Jeanne Hébuterne: the dominance of the elongated line of the head, neck and shoulders. It is as if Modigliani is still absorbed by the line of the sculptured heads he had concentrated on four years before, but here he has lost touch with the firm drawing that usually gives his work its hidden strength.

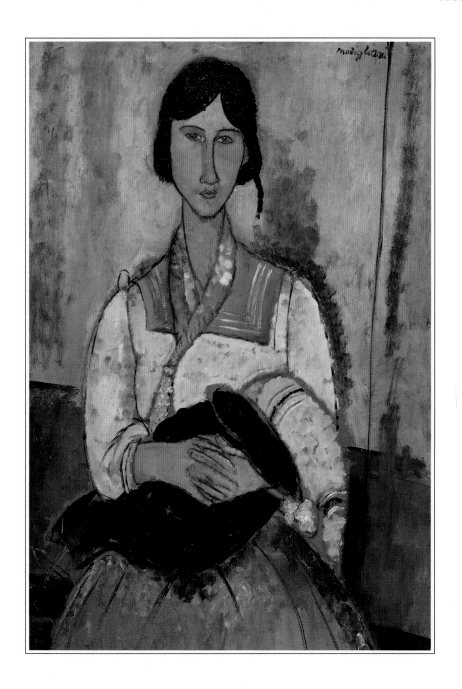

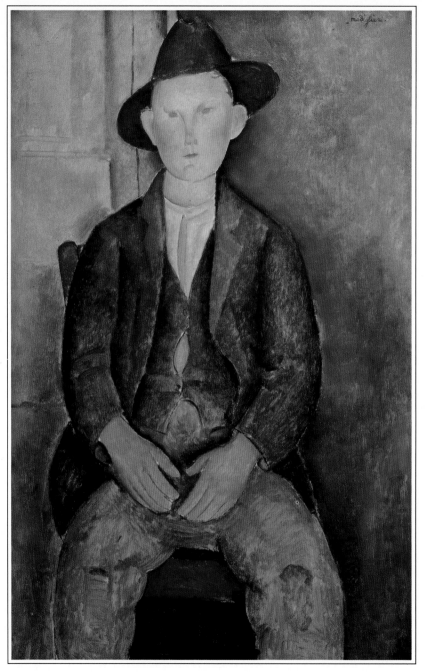

◁ **The Little Peasant** c.1918

Oil on canvas

THE PEASANT BOYS of the
South of France evoked in
Modigliani a quite different
response from the poor boys
of the city he had painted in
Paris. There is no emotional
response to the plight of the
poor expressed in pictures
like this. Modigliani has
recorded the fact that the boy
has grown out of his jacket
and waistcoat, but he has
chosen to do so in terms of the
detail of the subject; this is less
a portrait than an exploration
of mass, volume and the ways
in which the modelling of a
subject is affected by light and
is reminiscent of Cézanne's
late portraits, also painted in
the strong light of the South
of France.

> **Boy in Shorts** c.1918

Oil on canvas

MODGLIANI SEEMS TO HAVE
found a more middle-class
sitter here: a well-dressed
young boy in shorts and a
Norfolk jacket. It is possible
that Leopold Zborowski, who
had organised Modigliani's
stay on the Côte d'Azur and
who is known to have worked
hard at finding models for
him, obtained a commission
for a painting of the fair-
haired boy. Like others of this
period, the picture shows the
influence of Cézanne on
Modigliani's choice of colours:
a marvellous mix of light
ochres, pinks and greys,
skilfully blended as if for a
still life.

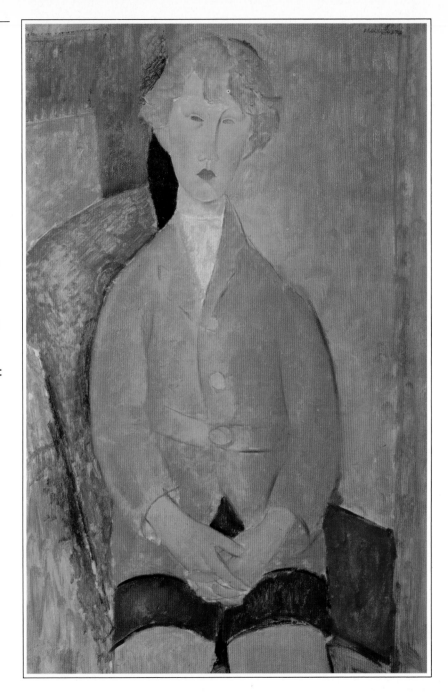

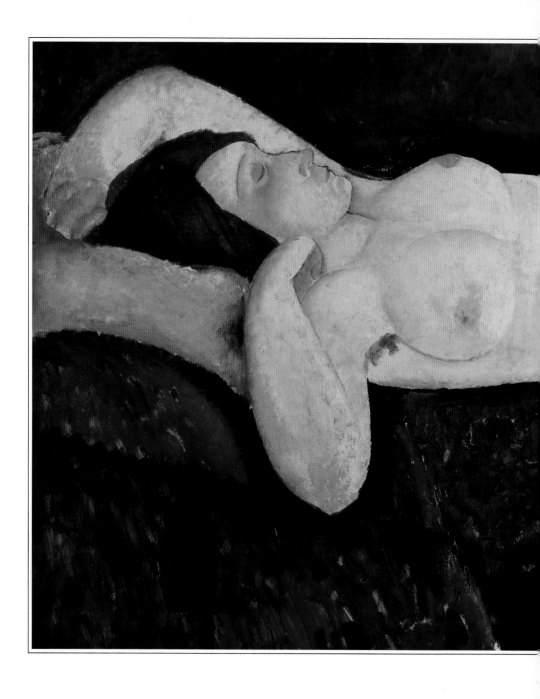

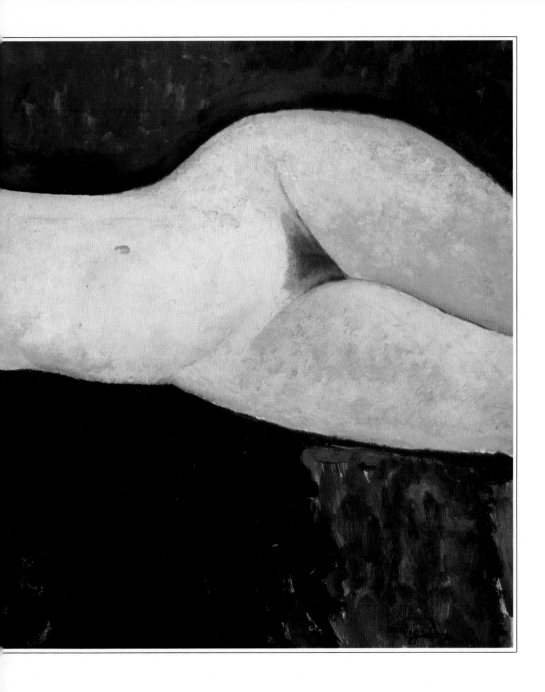

▷ **Portrait of Frans Hellens**
1919

Oil on canvas

HERE MODIGLIANI is painting
not a figure picture but a
portrait. The subject is the
writer and critic Frans Hellens,
whom Modigliani knew well.
Frans Hellens later recalled
that he sat for a portrait by
Modigliani in Nice in 1919, for
which the artist charged him
20 francs. Unfortunately,
Madame Hellens did not care
for the portrait because she
thought that it did not look
like her husband and
persuaded him to sell it. Some
15 years later when she saw
the portrait again, she realised
that she had been wrong, for
the portrait looked just like
one of their daughters.

Reclining Nude 1919

Oil on canvas

◁ *Previous pages 70-71*

THIS PAINTING'S TITLE in
French is *Le Grand Nu*, a title
more in the style of 'les
grandes baigneuses' of Renoir
and Cézanne than is usual
with Modigliani's nudes.
Although it is usually dated to
1919, some commentators put
it back to 1917, a date
suggested by its dark
background colour and by
Modigliani's treatment of the
torso, which is elongated to the
point of distortion. In both
these points it differs in
treatment from the three
superb nudes Modigliani is
known to have painted in the
last year of his life, all of which
are set against the lighter
backgrounds he had first used
in the South of France.

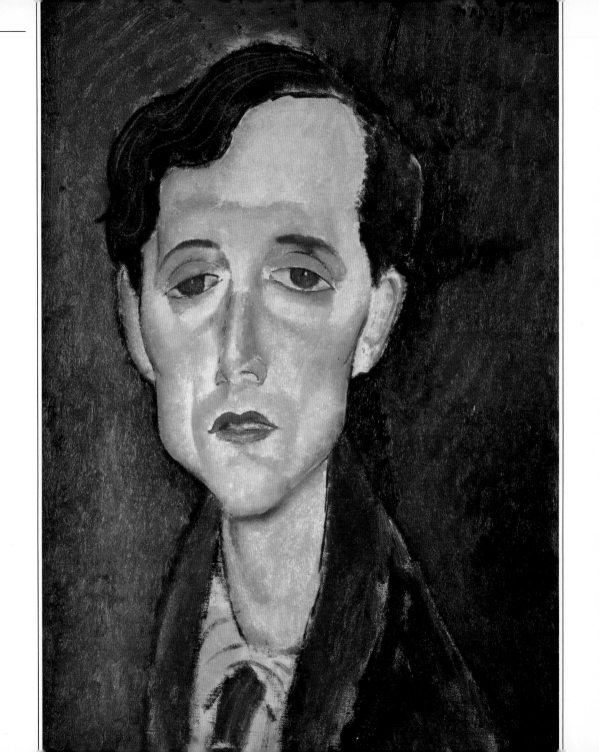

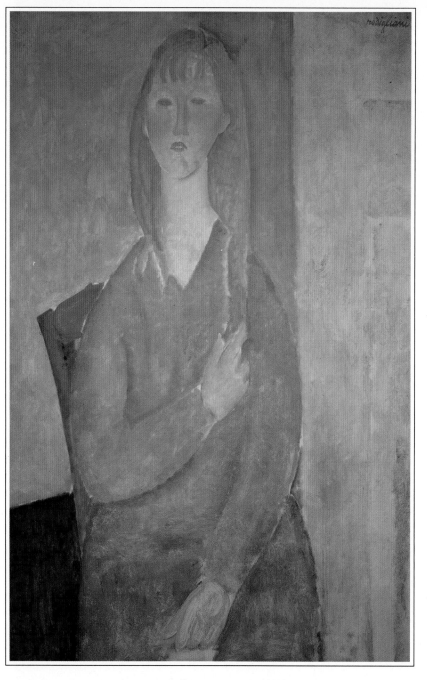

◁ **Girl in a Blue Dress** 1919

Oil on canvas

THIS IS POSSIBLY one of the las[t] portraits Modigliani painted i[n] his studio in the South of France: the chair the girl sits on, the background, and the lovely light colouring are common to many other pictures done during this prolific period. Modigliani retained the lighter palette in his work when he returned to Paris at the end of May 1919. He did not take back with hi[m] from the South of France any idea of painting landscapes o[r] still lifes, however; from now on he devoted himself to painting portraits, mostly of his friends in Paris.

Young Man with Red Hair

919

il on canvas

HIS IS A TYPICAL later period
Modigliani portrait: the sitter
 quite relaxed, informally
osed and gazing good
umouredly back at the artist.
he image is allowed to flow in
 series of elongated curves,
om the narrow head down
e long neck and merging
to the sloping shoulders.
he hands crossed lightly in
e lap with the picture
nishing at the knees are also
ighly characteristic of
Modigliani's treatment.

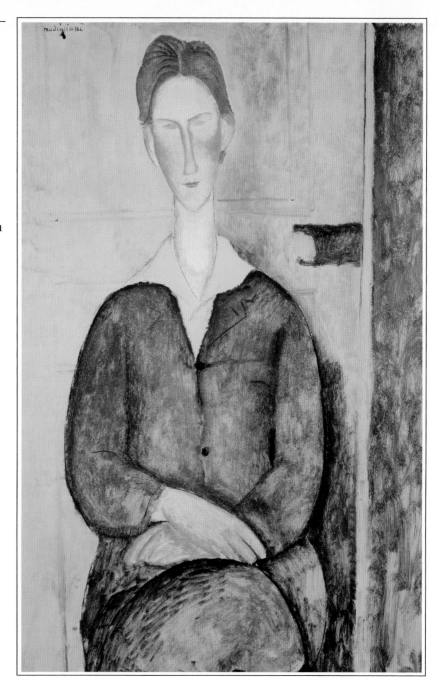

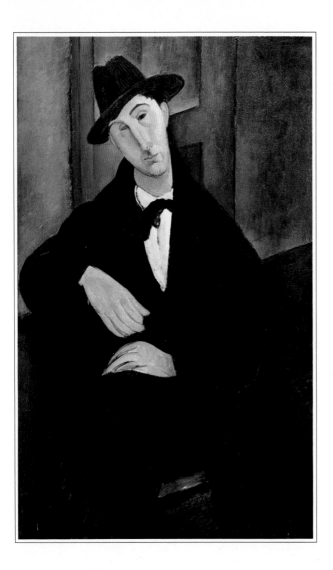

◁ **Mario** 1919

Oil on canvas

THIS AND THE self-portrait
which ends this book are
thought to have been the last
two paintings completed by
Amedeo Modigliani. Mario
Varvogli was a Greek musician
who became a regular drinking
companion in the artist's last
months. Modigliani paid
enough attention to the
portrait to do several
preliminary sketches and
studies for it. The final picture
shows a great preoccupation
with the character of his sitter.
Modigliani shows Mario
drooping wearily rather than
sitting in his seat, early
morning stubble clearly visible
and at odds with the evening
clothes he is wearing, though it
is also a clear indication that th
man has been up all night. He
looks rather sloppy, very tired
but also amused at the situation
in which he finds himself.

Detail ▷

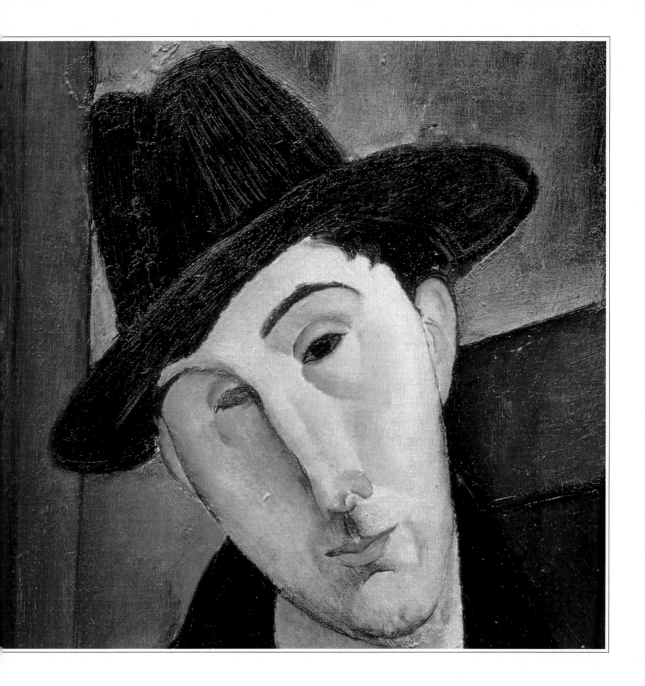

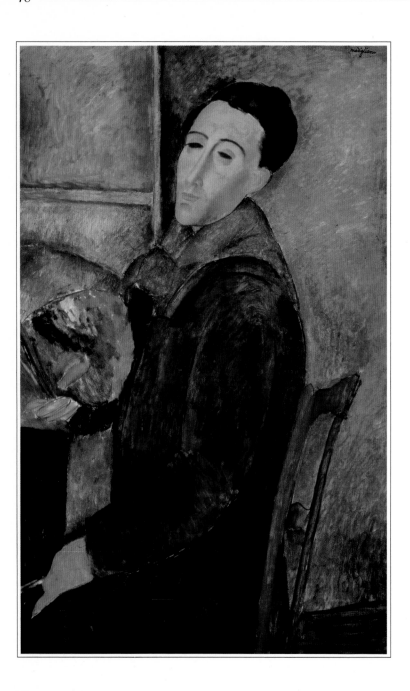

◁ **Self-Portrait** 1919

Oil on canvas

THE THIN, ALMOST emaciated features in this self-portrait in oils, the only one Modigliani known to have done and to have called a self-portrait, are hard to reconcile with the last photograph of the artist, in which he looks haggard, unkempt, unshaven and coarse-featured. But there is a drawing of Modigliani reading in bed, done by Jeanne Hébuterne in the weeks before his death, which shows just the same fine, almost aesthetic features. Perhaps the artists, recognising that tuberculosis and approaching death bring their own refinement, were making truer portraits of Modigliani than the camera.

ACKNOWLEDGEMENTS

The publisher would like to thank the following for their kind permission to reproduce the paintings in this book:

Bridgeman Art Library, London/William Young & Co., Boston: 9; /**Private Collection**: 13, 38, 51, 63, 73, 74; /**Christie's, London**: 22, 53, 59 *(also used on front cover, back cover detail and half-title page detail)*, 65, 69, 75; /**Metropolitan Museum of Art, New York**: 33; /**Galleria d'Arte Moderna, Milan**: 34; /**Art Institute of Chicago**: 37; /**Solomon R. Guggenheim Museum, New York**: 44-45, 60; /**Musée d'Arte Moderne, Villeneuve d'Ascq**: 47; /**Konstmuseet i Ateneum, Helsinki**: 54; /**National Gallery of Art, Washington DC**: 67; /**Tate Gallery, London**: 68; /**Musée Nationale d'Art Moderne, Paris**: 55

Musée National d'Art Moderne, Paris: 10
Guggenheim Museum, New York: 11, 57
Tate Gallery, London: 12
Art Institute of Chicago: 14
Feder und Rote Tusche, New York: 17
Phototheque des Musées de la Ville, Paris: 18
Staatsgalerie, Stuttgart: 25
Art Museum, Princeton University, New Jersey: 28
Art Gallery, Ontario: 29
National Gallery of Art, Washington DC: 39, 48-49, 52
Albright-Knox Art Gallery, Buffalo, New York: 64
Christie's, London: 76
Museu de Arte, Sao Paulo: 78

Every effort has been made to trace the copyright holders and we apologise in advance for any unintentional omissions. We would be pleased to insert the appropriate acknowledgement in any subsequent edition of this publication.